M000094015

All inquiries should be addressed to:
Barron's Educational Series, Inc.
250 Wireless Boulevard
Hauppauge, NY 11788
www.barronseduc.com

ISBN-13: 978-0-7641-6331-9
ISBN-10: 0-7641-6331-0

Library of Congress Control Number: 2009938073

Printed in China
9 8 7 6 5 4 3 2 1

Gotta Love Cats!

Fran Pennock Shaw

Ever curious,

ever hopeful,

the cat waits

for life's next great

surprise!

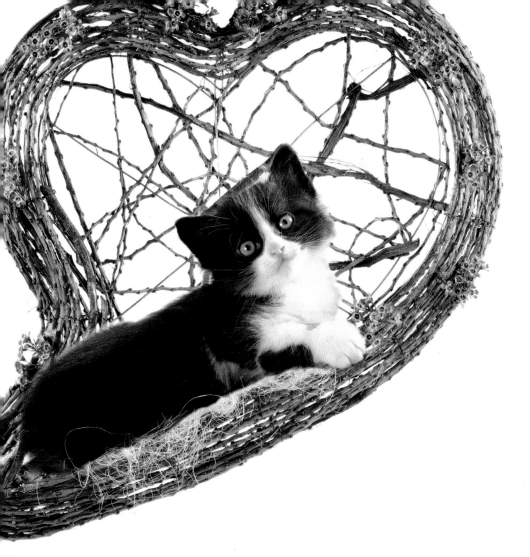

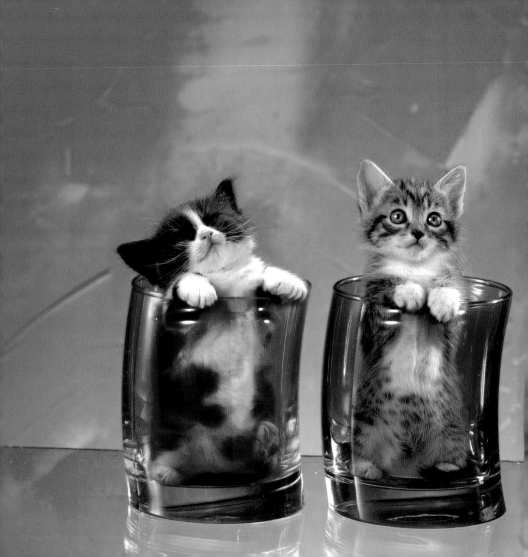

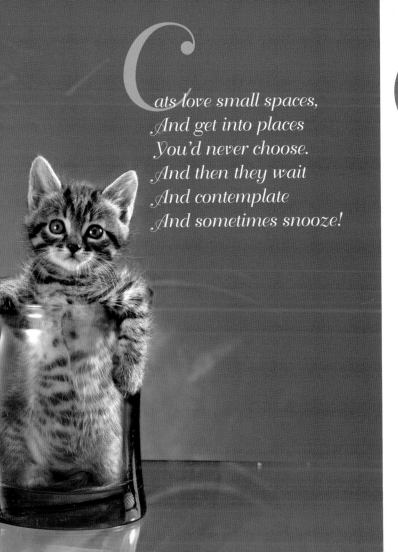

*C*ats love small spaces,
*A*nd get into places
*Y*ou'd never choose.
*A*nd then they wait
*A*nd contemplate
*A*nd sometimes snooze!

Clancy

Fancy

Sleepy

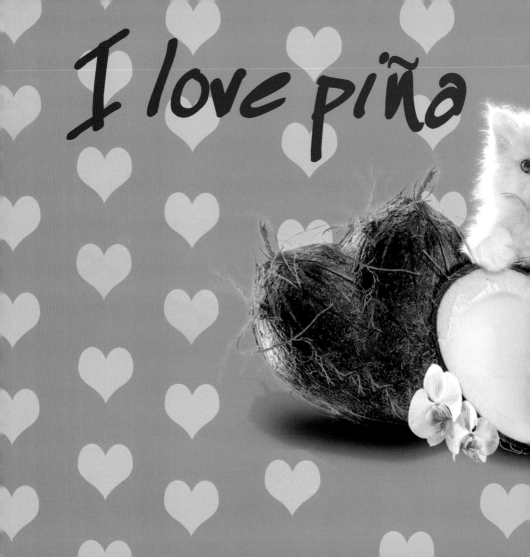

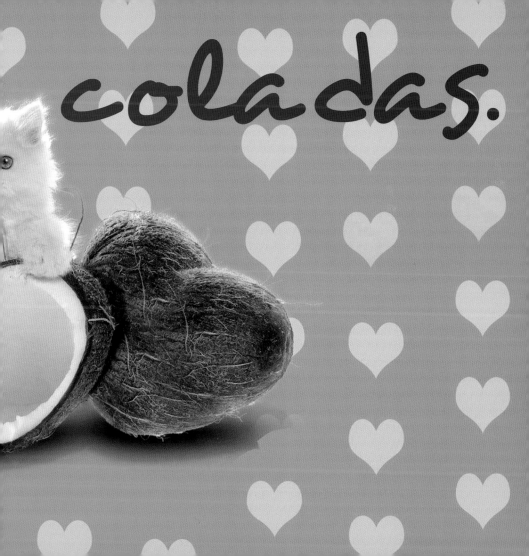

coladas.

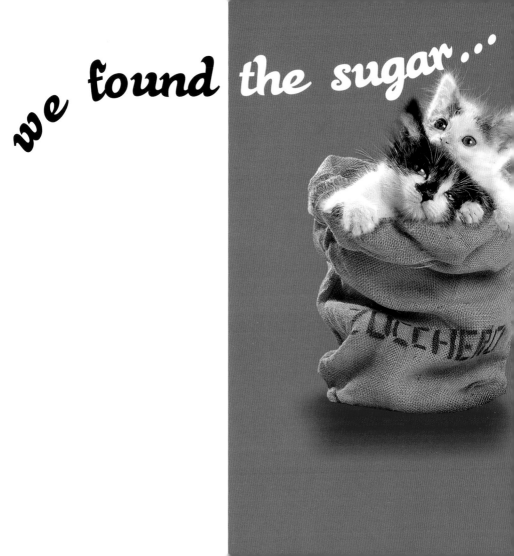

we found the sugar...

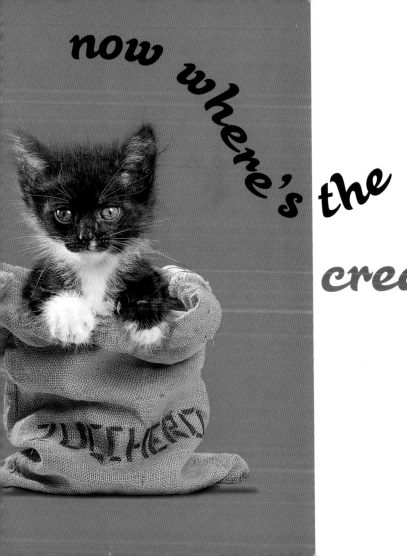

now where's the cream?

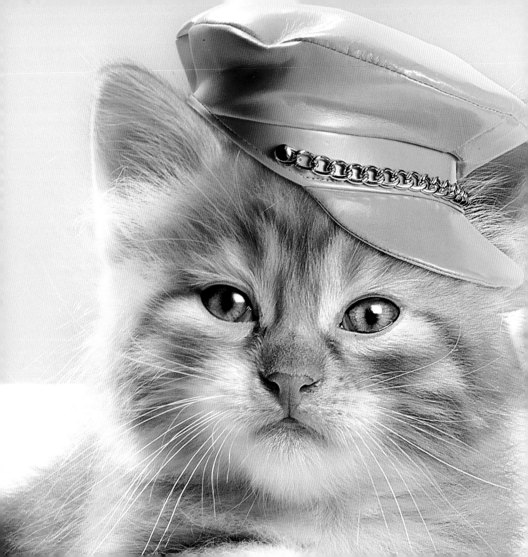

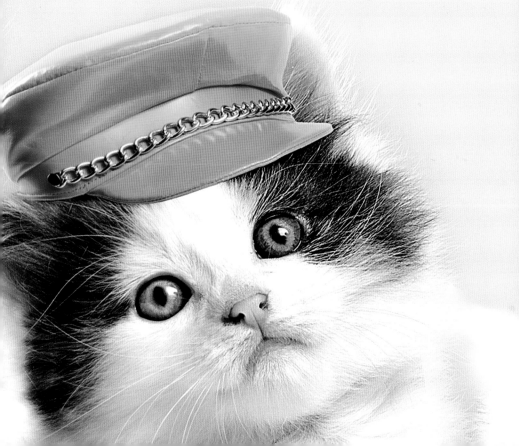

One cat in a hat is a Seuss tale of old,
but two cats in hats is a story untold.

Give your kitten love
And shower her with praise,
Then just watch her grow
Into a cat bouquet!

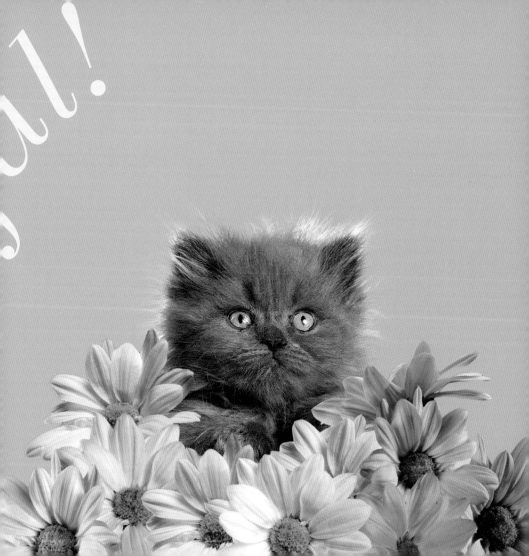

Let your cat rule the roost, and he'll make your house a home.

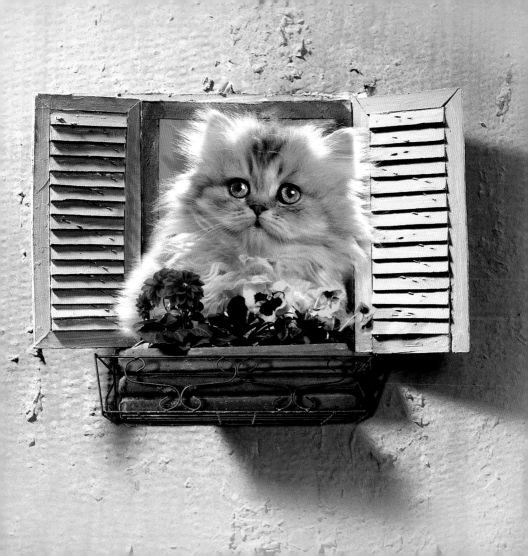

Several catnaps a day

keep life's stresses away.

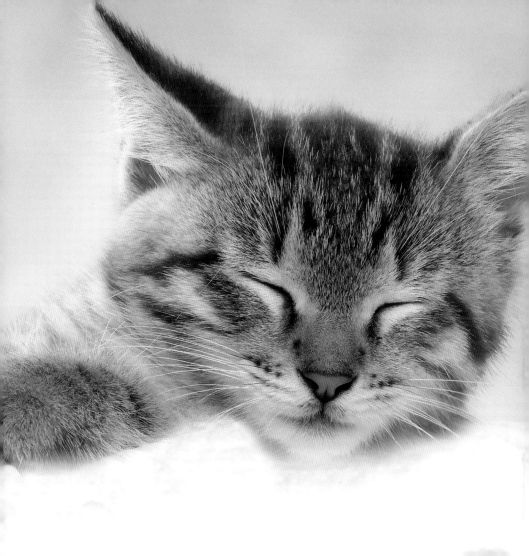

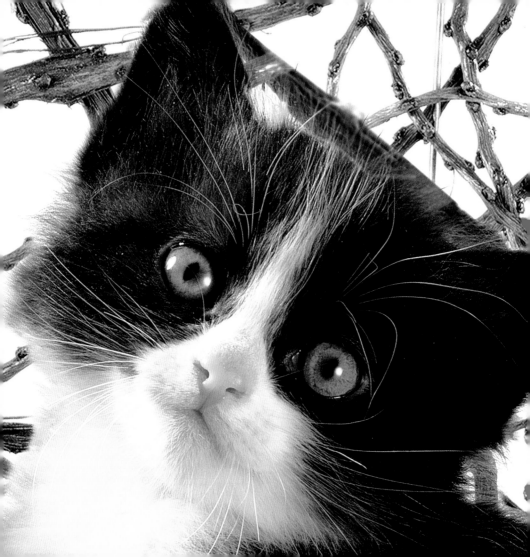

Open your heart to a kitten,

And it comes as no surprise,

In an instant you'll be smitten,

By those playful, pleading eyes.

When a cat
chooses to be
with you,
it's the greatest
compliment!

Every cat is an individual; no two are the same.

Nurture your kittens and they will blossom… naturally.

*A*ll that pouncing and stalking

IS EXHAUSTING!

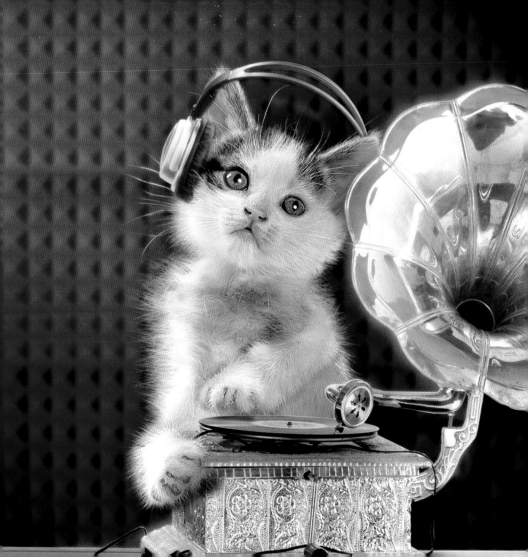

*The sweetest music
you'll ever hear
Is the sound of a
pussycat's purr;
The sweetest music
to a cat's ear
Is to say that you
love only her!*

Cats seek answers to those universal questions:
Who am I?
Why am I here?
What's for dinner?

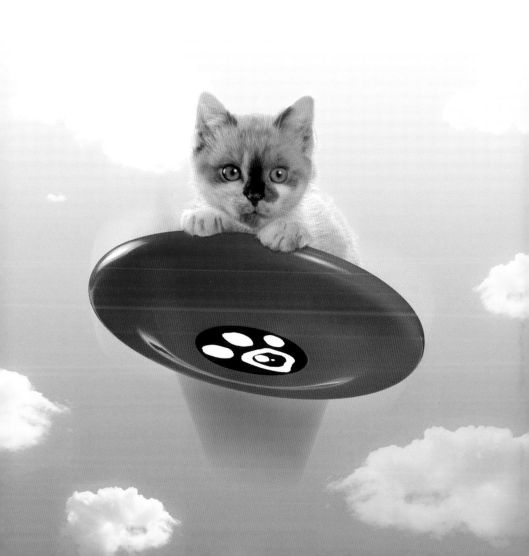

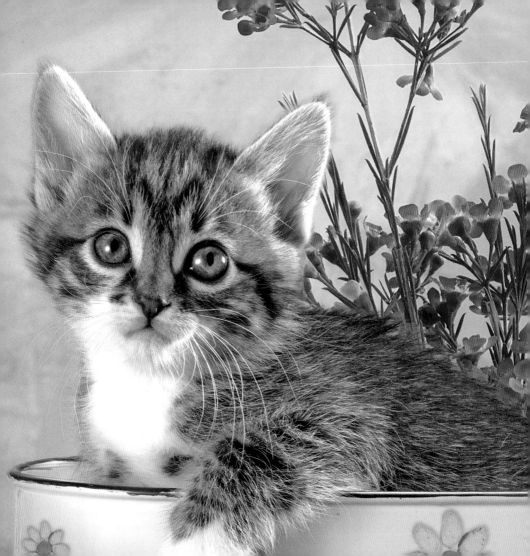

What a

purr-fect day!

*Give a
little cat your love,
and you'll get it back
a thousandfold.*

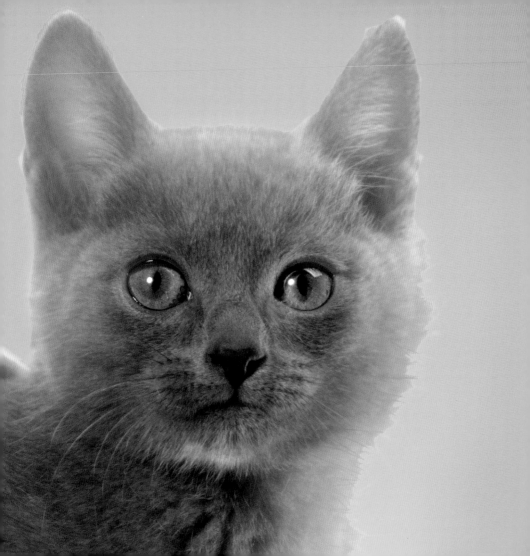

Don't let that innocent look fool you... there's mischief afoot!

A trick?

Cats don't do tricks!

If you live in my house, you follow my rules:

Pet me,

Play with me,

Feed me,

Adore me.

THAT'S
CAT-titude

If you have nine lives,

WHY NOT LIVE ON THE WILD SIDE?

And if elected, I promise a ball of yarn and free sardines for all...

Double the laughter
And double the fun,
'Cause having two kittens
Is better than one.

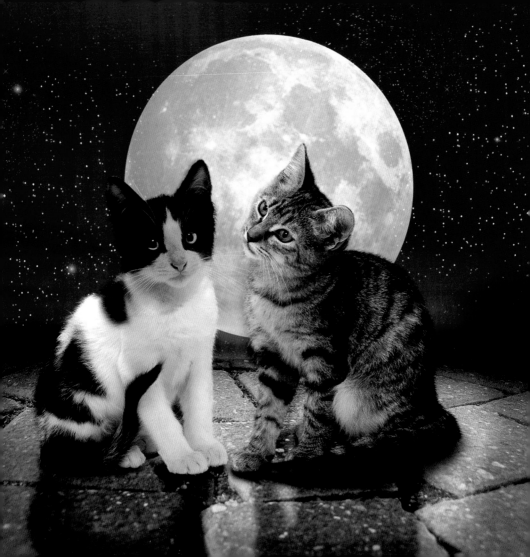

I'M NOT REAL BIG ON
SHARING, BUT...
I WANT TO SHARE MY
LIFE WITH YOU.

Star,

Aurora,

and the night.

\mathcal{K} ittens aren't all sugar and spice... sometimes they can be real sourpusses.

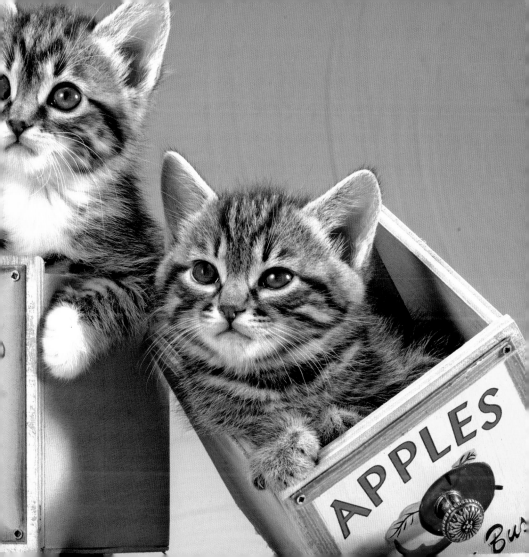

A dog may idolize you,

but a cat understands you!

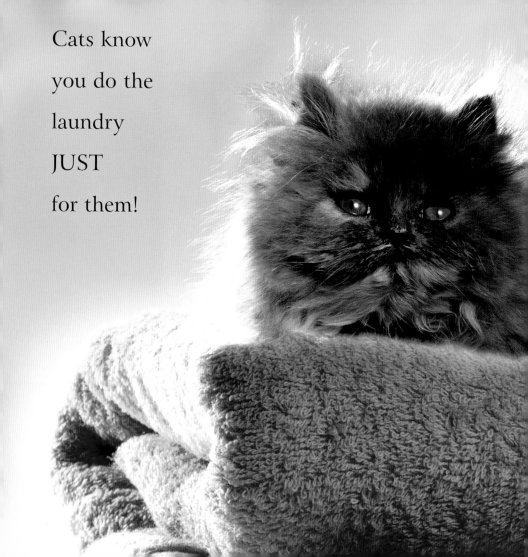

Cats know
you do the
laundry
JUST
for them!

The trick to making

a cat exercise

is to find the right

V E H I C L E !

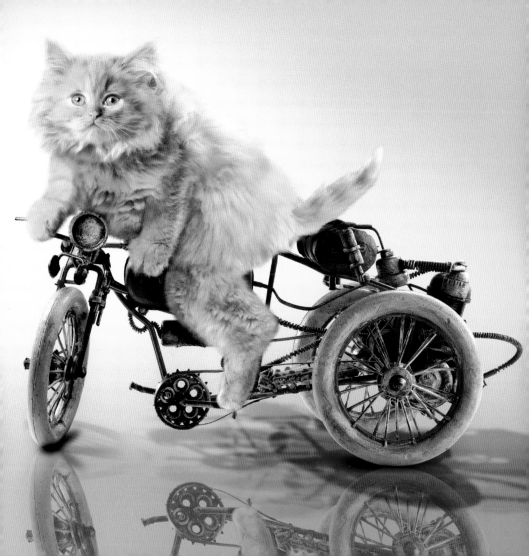

the conqueror

Brave little cat,

you've conquered my heart,

won over my mind,

and captured my soul.

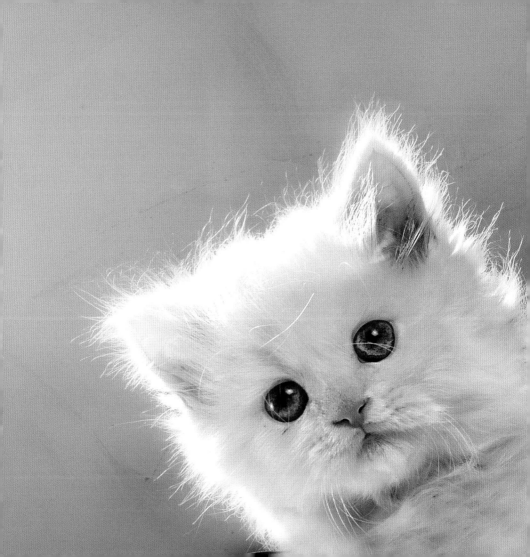

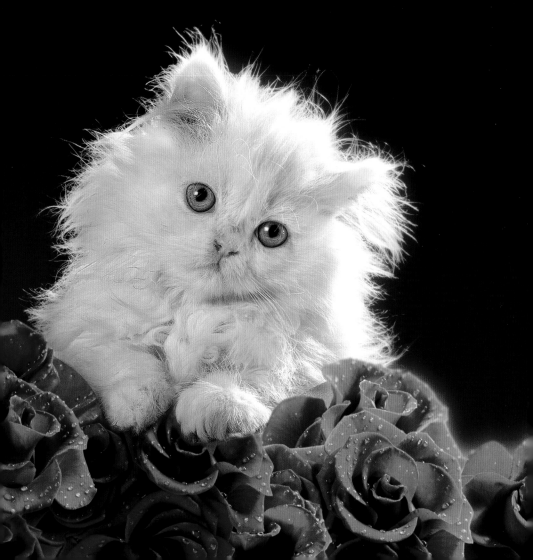

A cat may not

respond to your call,

but that's only because

she has a higher calling.

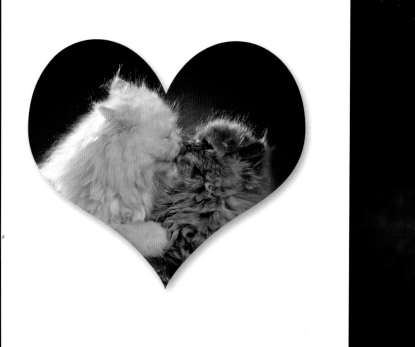

Though the night was made for loving,
And the day returns too soon,
Yet we'll go no more a-roving
By the light of the moon.

LORD BYRON
from "So, We'll Go No
More A-Roving"

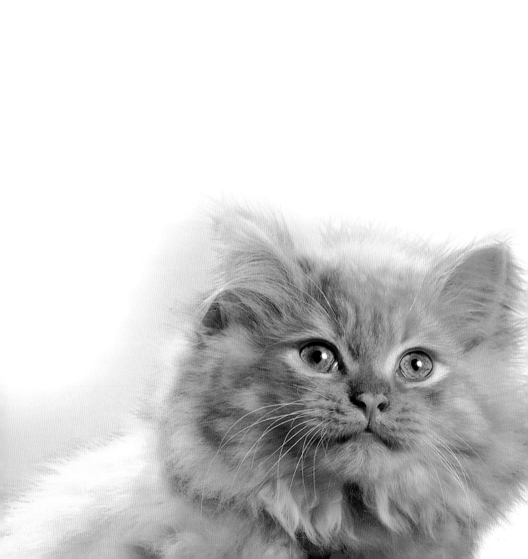

Inside the smallest kitten

beats the heart of a lion.

Like a flower
plucked
Time with
a cat is
precious.
Treasure
each
moment.

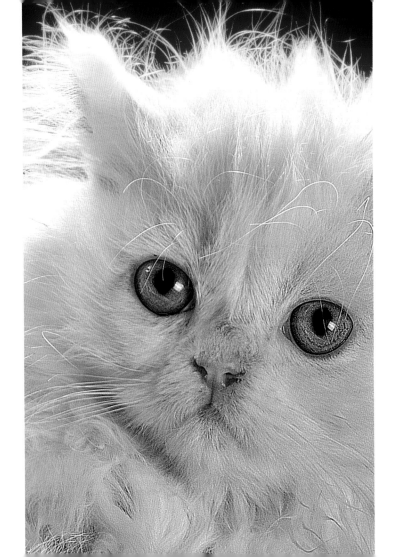

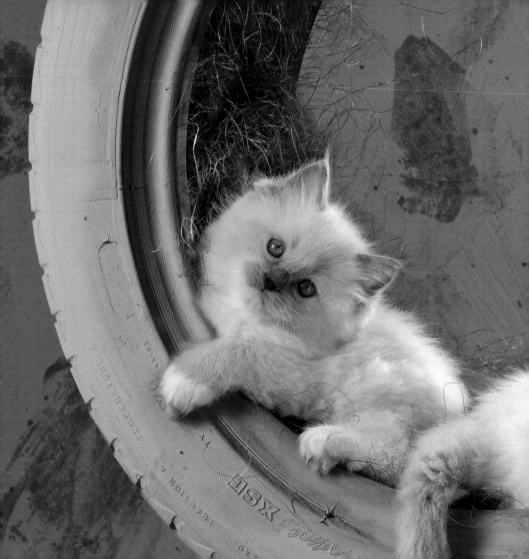

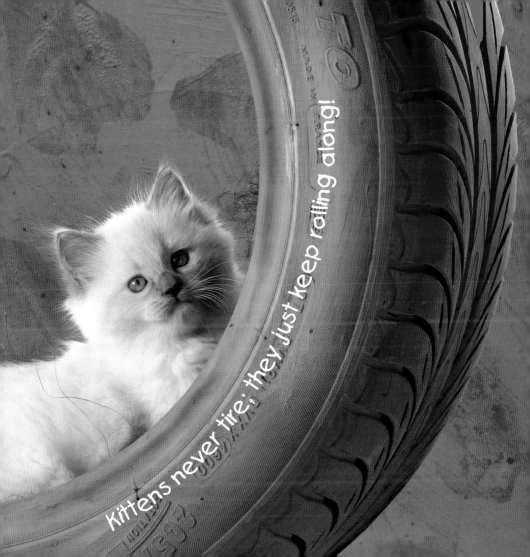
Kittens never tire; they just keep rolling along!

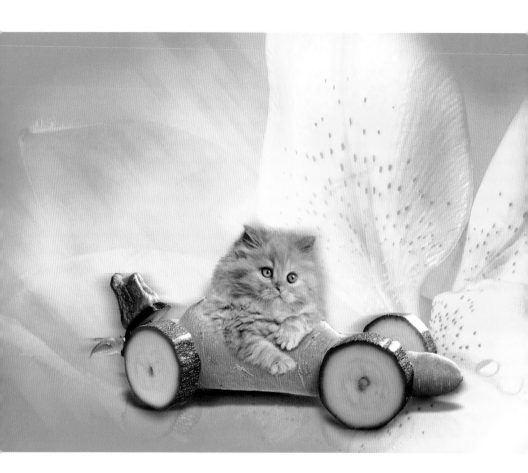

All things are
paws-ible for
a cat!

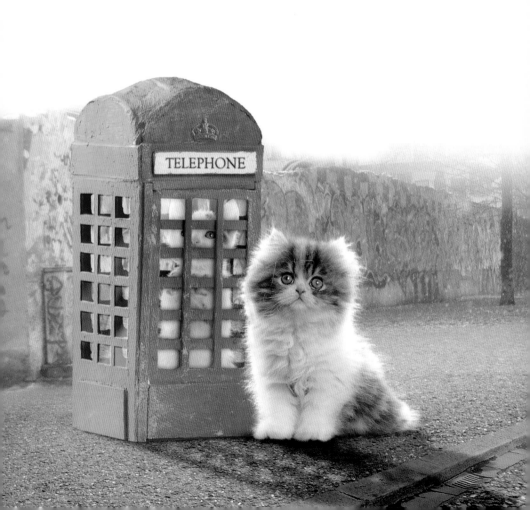

an you hear me meow?

Mom says my shedding

Is driving her dotty,

So making fur clothes

Should be our new hobby.

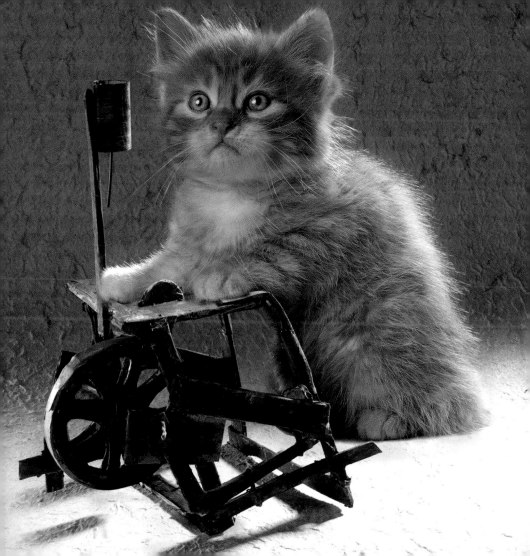

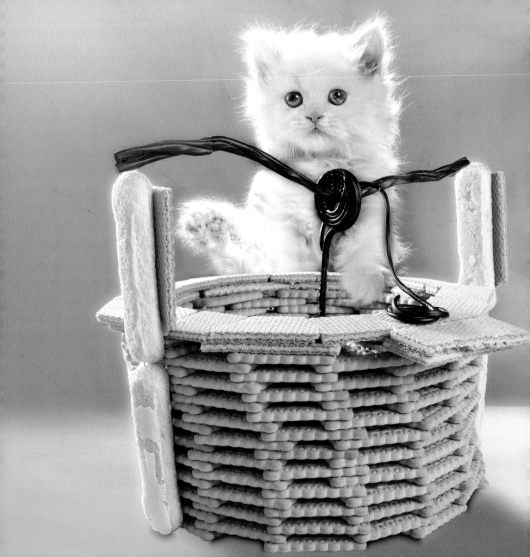

At a wishing well, a little cat

Threw in a coin, then nervously sat;

He wished to be king,

And rule everything,

Unaware he already did that!

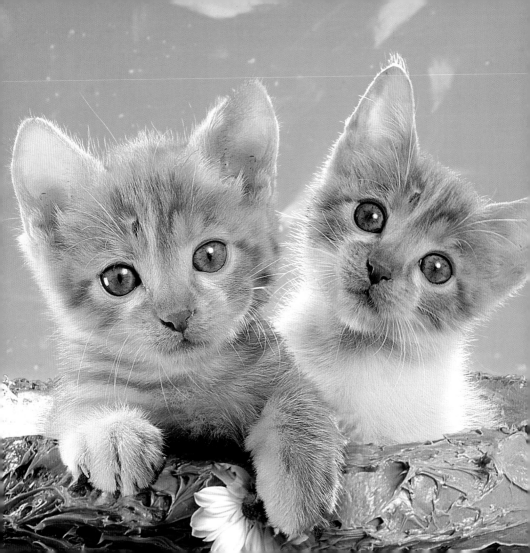

We're just exercising
our constitutional
right to the purr-suit
of happiness!

*W*hat can I say?

I get bored easily.

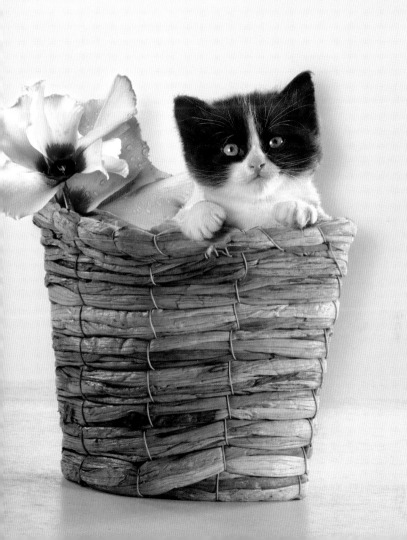

Nothing picks you up in the morning like Vitamins C and K—
Cats and Kittens, that is.

A CATalogue

of Cuteness

To a cat,
there is no
tomorrow.
She lives in
the present.
That is her gift.

A cat can enjoy
The simplest of things:
A scratch on the chin,
Or the song a bird sings,
A soft place to sleep,
The warmth of the dawn;
He'll savor each moment,
And then he'll move on.

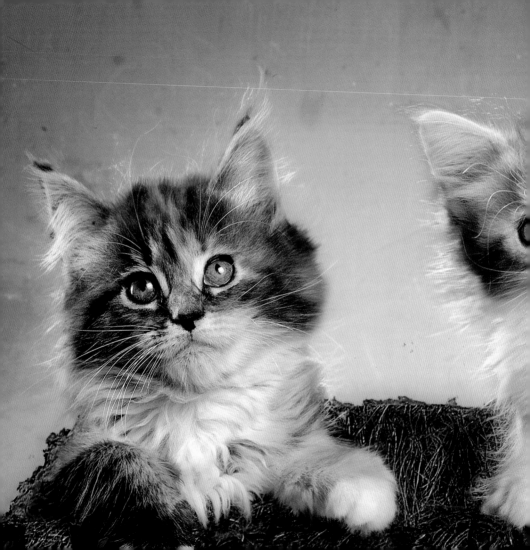

Cats speak from
the heart...
if you know
how to listen.

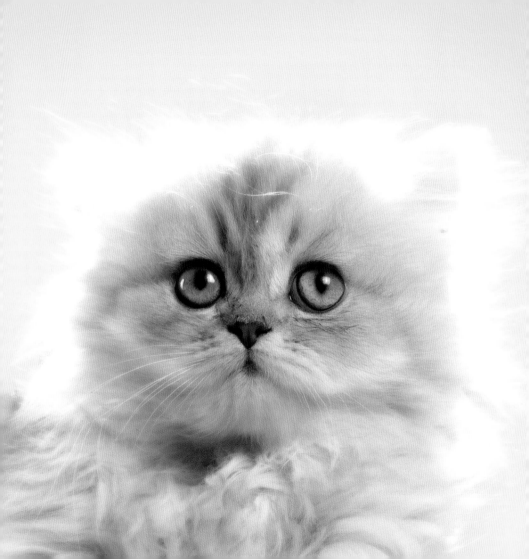

It's hard to define

What's in a cat's mind,

But we can surmise,

That his thoughts are wise!

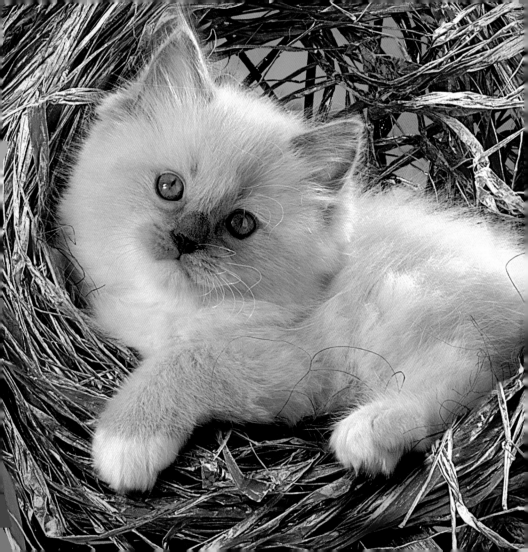

Every day's
a holiday,
to a cat.

Cats will do anything
you want...
as long as they want
it too!

If little madame cat

Has got you feeling that
You're nothing but a slave
In her feline enclave;
And she steals your best seat,
Your pillow and your sheet,
And refuses her food
When she's not in the mood;
Simply focus on this
To appease the princess:
You need only pet her

To make things much better!

Little sun worshipper,

Following the light,

Bidden by its rays,

Basking in its arms;

She purrs in contentment

To share its warm embrace.

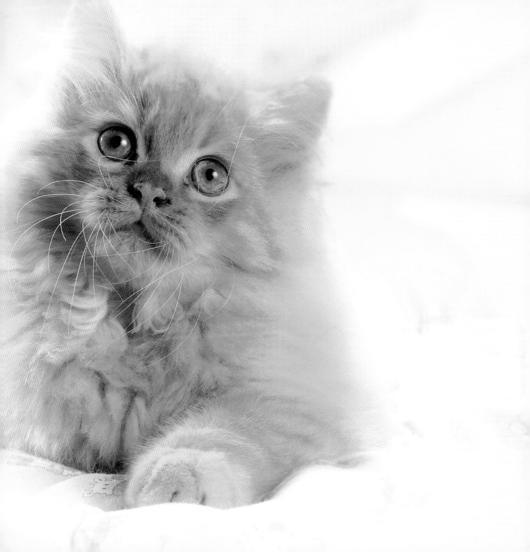

"*I am NOT caterwauling! It's karaoke night.*"

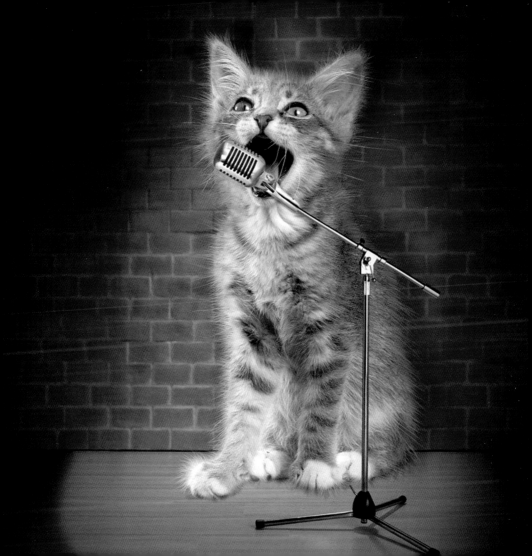

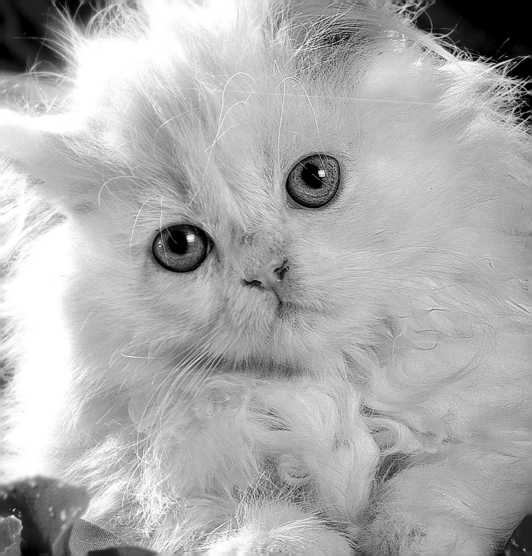

With

a cat,

everything's

negotiable.

Kittens
have
a
way
of making
YOU play.

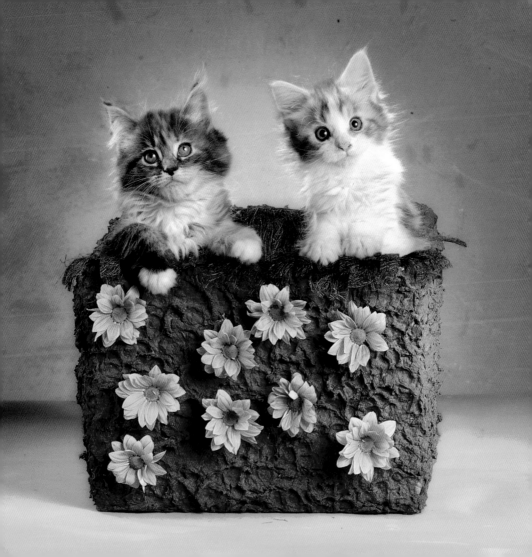

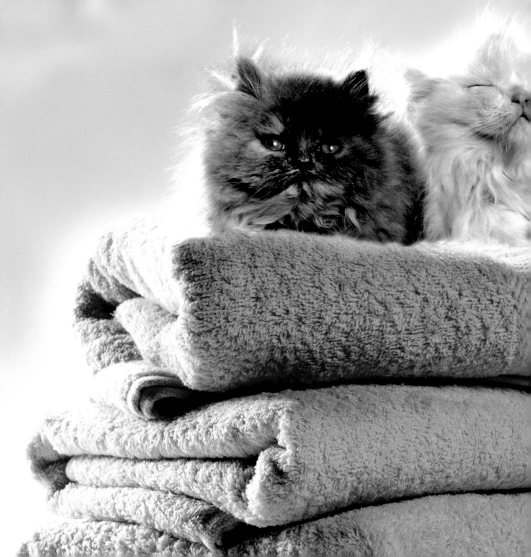

Y

You rest your eyes.

I'll take the first watch.

We're just

hangin' out…

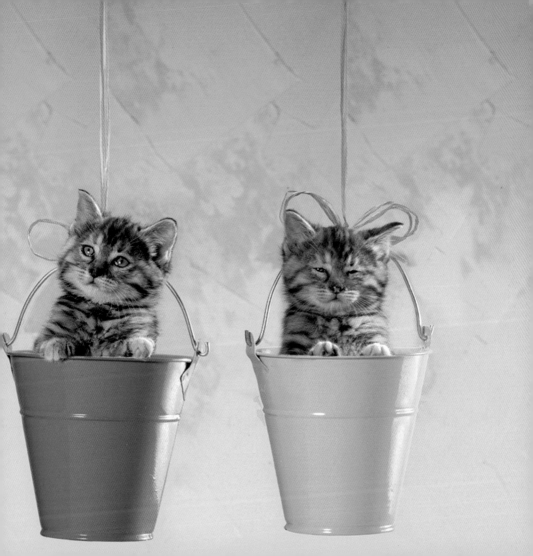

Here's the whole

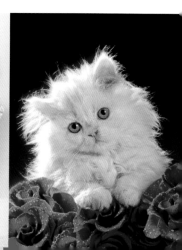

kit 'n caboodle

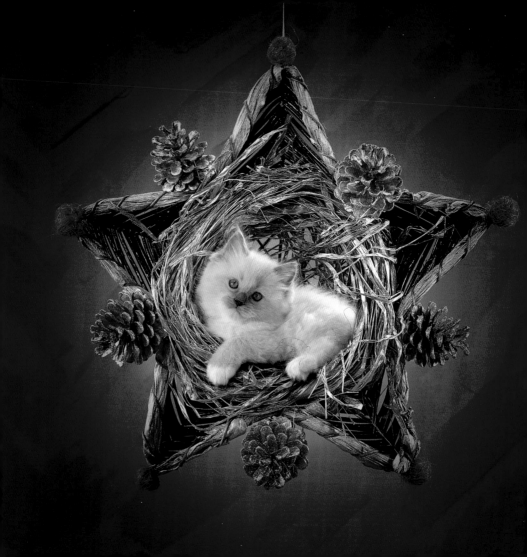

I'm talking

star quality here!

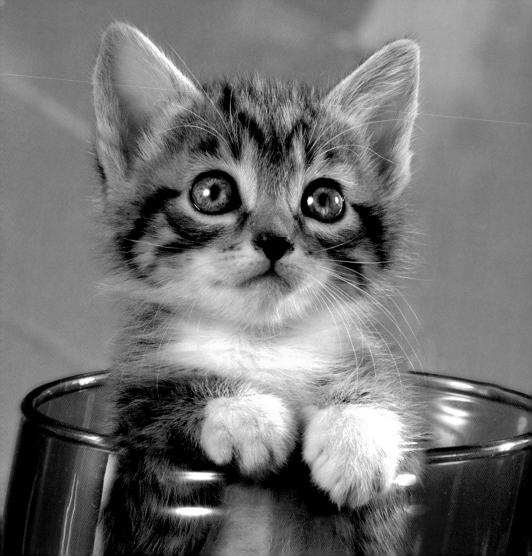

Kitty in a cup,

So cute…

You could drink

her right up!

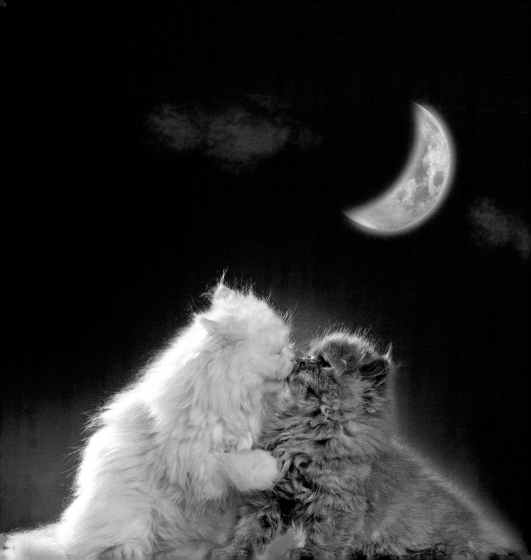

Cats are great lovers,
When given a chance;
Patience uncovers
Their gift for romance.

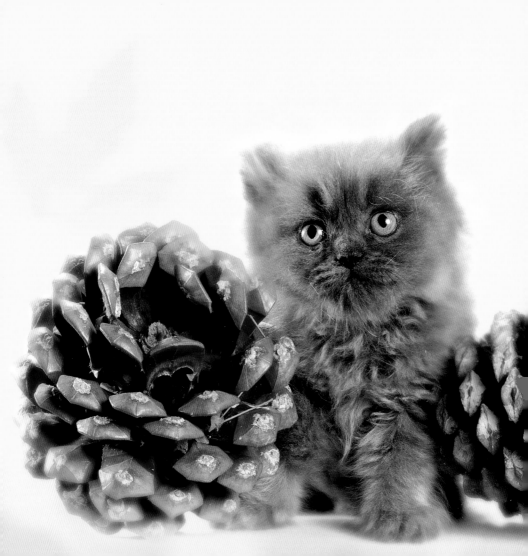

Cats are for all seasons.

I got my

master's degree in master manipulation.

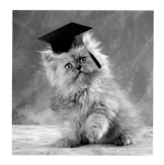

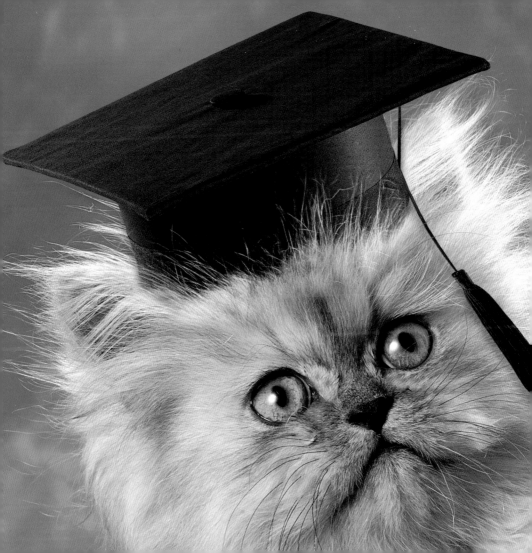

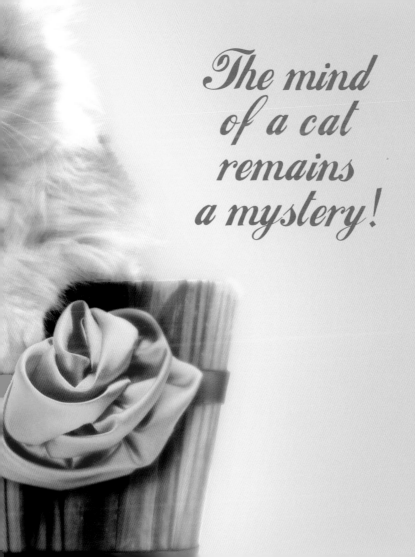

*The mind
of a cat
remains
a mystery!*

*Cats can teach us
So many things:
To find joy and
 comfort,
In all that life brings.*

wisdom

Four Cat Facts:

Cats are simply one-derful!

Cats are adorable, two!

Yes, cats can be three-atrical

But they're always there four you!

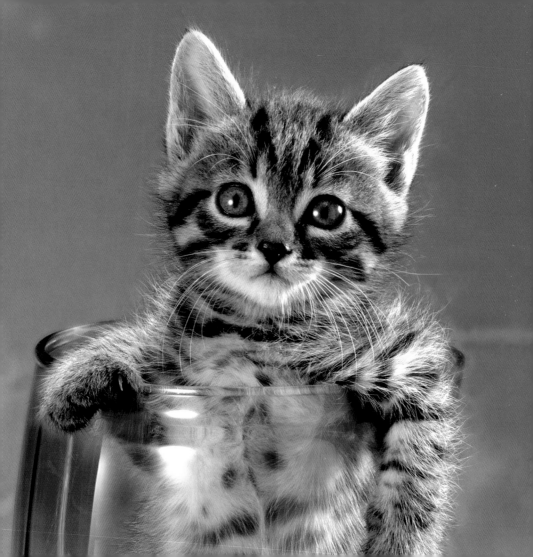

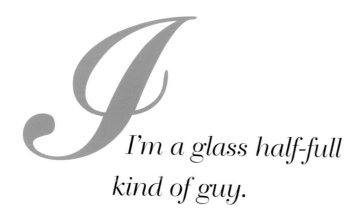

*I'm a glass half-full
kind of guy.*

Cats are incredibly

patient—

manipulator

they'll let you entertain

them all day long!

*A little nap
can be so-oo
refreshing!*

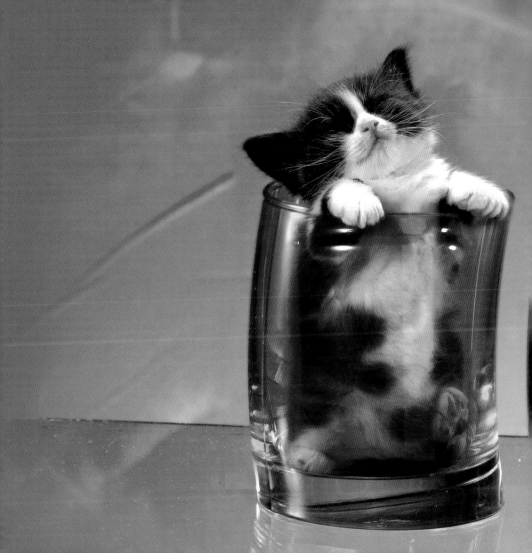